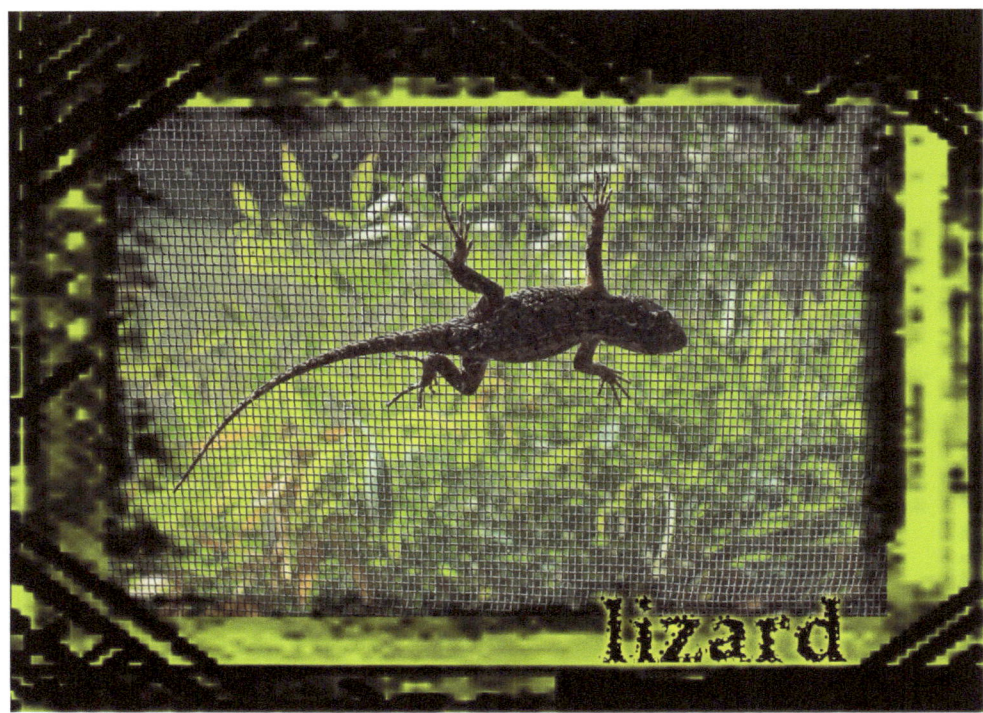

For about a month this summer, a tiny lizard took up residence between my kitchen window and screen. Every morning, he'd wriggle through a gap in the corner of the screen, and wander out to the center to sun his belly. I managed to grab a few shots one morning, while he slept in the summer sun.

Notices & Disclaimers

not just another bland, boring how-to thing...

TEN TWO studios

Visit us online at
www.TenTwoStudios.com
or email at
TenTwoStudios@yahoo.com

Bad Influence is a printed zine produced by Lisa Vollrath of Ten Two Studios. The articles and images presented here are for your entertainment only. By purchasing a copy of this zine, you agree not to scan or copy any portion of it for any reason. You may not print out copies of articles for your friends, or post any portion of the zine to message boards, web sites or online groups. Doing this is a copyright violation. Don't do it.

Photographs on pages 8-9, © 2006 Diane Ferguson. Photographs on pages 12-16, © 2006 Tamelyn Feinstein. Photo on page 18, © 2006 Jen Worden. Photos on page 19, © 2006 Annie Yu. All other contents copyright © 2006 by Lisa Vollrath and Ten Two Studios. All rights reserved worldwide. No part of this document may be reproduced or transmitted in any form, by any means (electronic, photocopying, recording, or otherwise) without the prior written permission of the publisher.

This publication is protected under the US Copyright Act of 1976 and all other applicable international, federal, state and local laws, and all rights are reserved.

Any trademarks, service marks, product names or named features are assumed to be the property of their respective owners, and are used only for reference. There is no implied endorsement if we use one of these terms.

A Few Words From Lisa

I realized as I was putting together this issue that I'm suddenly a lot more interested in other people's work than I am in my own. That may sound like a dumb thing to hear from someone who spends so much time writing and photographing her own art, but there it is.

This month, I tracked down talented photographer Tamelyn Feinstein, and got to know her a little. Her photos inspire me because they're so elegant, yet so accessible. She really does photograph everyday things, but she does it with a style that makes me want to stretch further with my own photos.

I also managed to wrangle photos and artwork from a handful of brave souls who responded to my call for art. I hope to shake work loose from more of you in future issues---because your work inspires me, and makes me want to work harder at my own.

Lisa

Artists in This Issue

Diane Ferguson lives in the Houston area, and in addition to her mixed-media work, is an accomplished weaver and fabric artist. Her art can be seen in her blog at soonerorlater.blogspirit.com.

High atop a rural Nova Scotian drumlin, **Jen Worden**'s art is influenced by her physical surroundings. Mixed with paper and paint, rusty things and nature's detritus, it is this journey that continues to intrigue and enthrall, and, hopefully, grow as an artist.

Annie Yu is addicted to art journaling, collage and Flickr. She lives in San Francisco and likes to go to dollar stores, admire Victorian houses and ride Muni around the city.

Lisa Vollrath is a prolific mixed-media artist. Her work covers a multitude of techniques, from altered books to collage, from artist trading cards and decos to textile art and costume design. She has written dozens of books and how-to articles for arts and crafts publishers. Her current work can always been seen on her ever-growing web site, LisaVollrath.com.

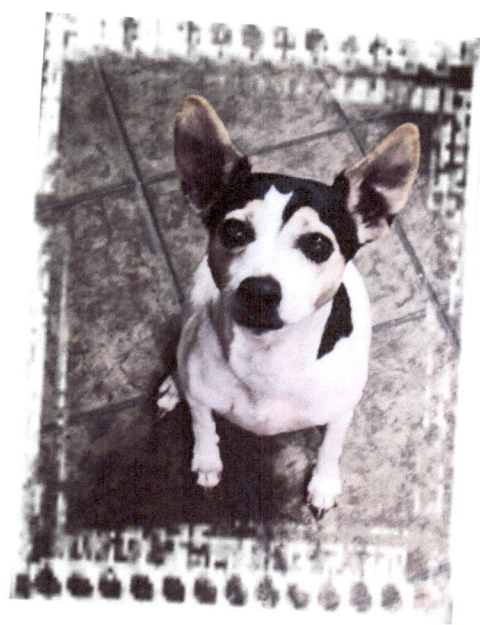

Exploring Self-Portrait Photography

If you need a willing live model, you really don't have to look any further than the mirror. Artists throughout history have used self-portraits as a way to explore ideas and try new techniques.

Two things made me drag my feet about taking my own photos: I'm really not a very good photographer, and I just loathe having my picture taken. One day, I was working on a piece that needed a face in a particular expression. I remembered seeing a piece of film showing Disney animators making faces in mirrors, and then using those expressions in their character sketches. Maybe I could find a way to use my own self-portraits to fill in the empty space in my work.

Taking my own photo was a big step for me. I'm not a pretty girl, and when I started photographing myself in 2003, I was quite heavy. Facing myself in the mirror, and then viewing dozens of photos of myself after each session was initially a painful experience. It took me quite a while to get past not liking my fat face or the blotches on my face, and get to a place where I was looking at things like lighting, composition and improvement in my ability as a photographer. It was strange to be at a point where I felt really liberated in my mixed-media work, and so inhibited and self-critical of my physical self.

After three years of doing self-portraits, I'm a little less inhibited about the final products. I've been using my own photos in quite a few of my pieces, which has helped me towards my goal of using only original materials in my work.

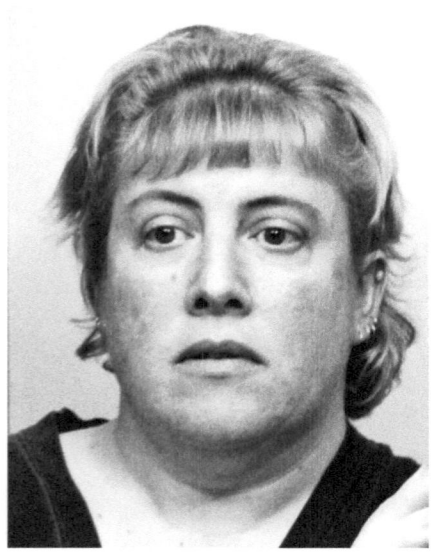

Can you see the fear in my eyes in this 2003 self-portrait? It's not taken from a good angle, poorly lit, and very grainy---but it's a start.

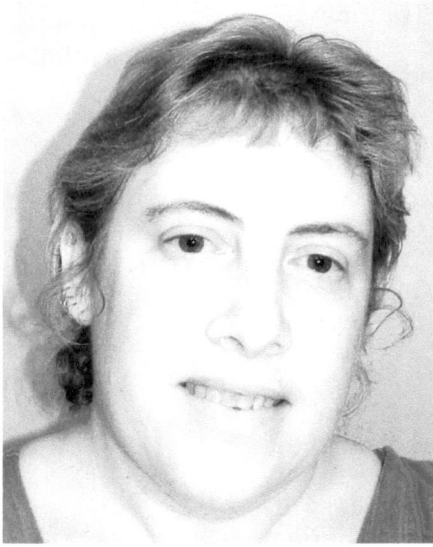

I took this shot in 2004. I did a lot of retouching to remove freckles and lines---something I probably wouldn't do today.

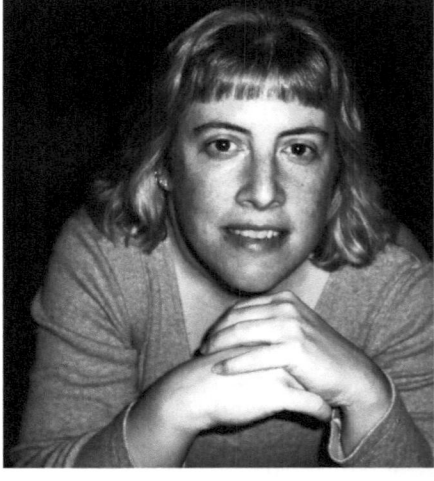

This photo is from a session in 2005. I was learning to use the timer on my new camera, so I was setting the timer, then plopping myself on the sofa to wait for the shutter to click. I can't believe I look this natural.

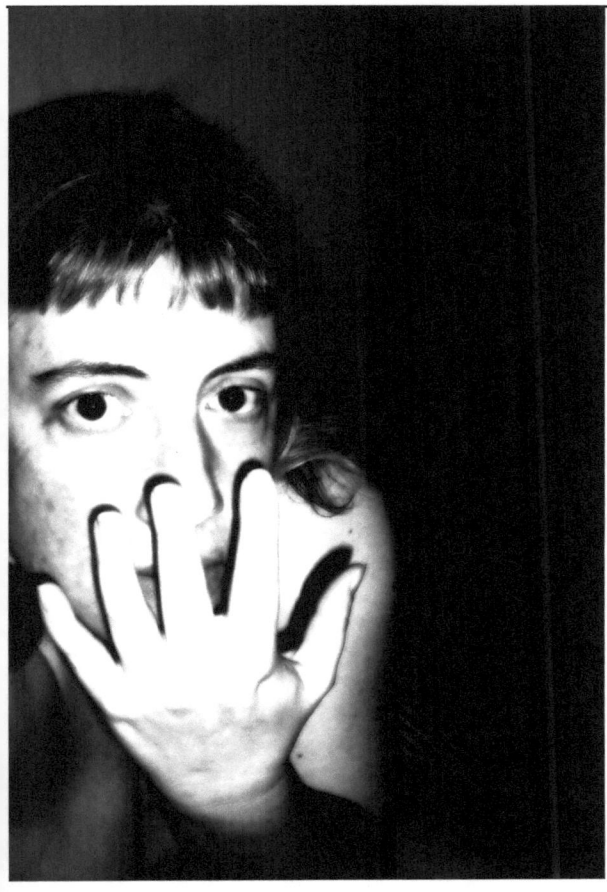

As I've grown more comfortable photographing myself, I've also done more experimentation. Not every self-portrait I take has to be a glamour shot. Sometimes, I need something odd or creepy for a piece, like the photo at left.

I needed a photo for a piece about the war in Iraq, and I really had to use something original rather than something from the news wires. With a scarf from the back of my closet, and a little digital manipulation to darken my features, I ended up with the perfect image.

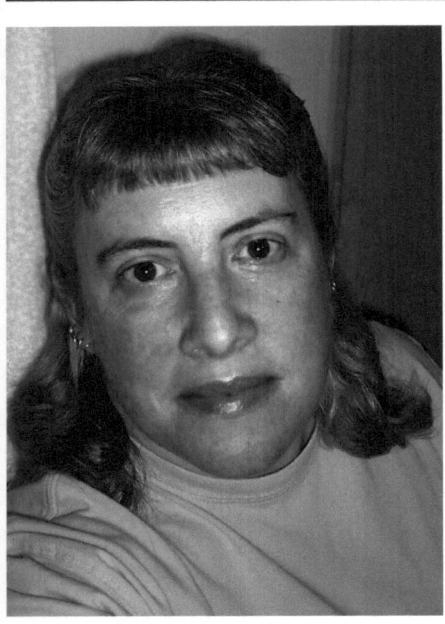

I needed a photo of myself for a LiveJournal post earlier this year, for a friend who was asking to see what everyone looked like that day. Look---no fear!

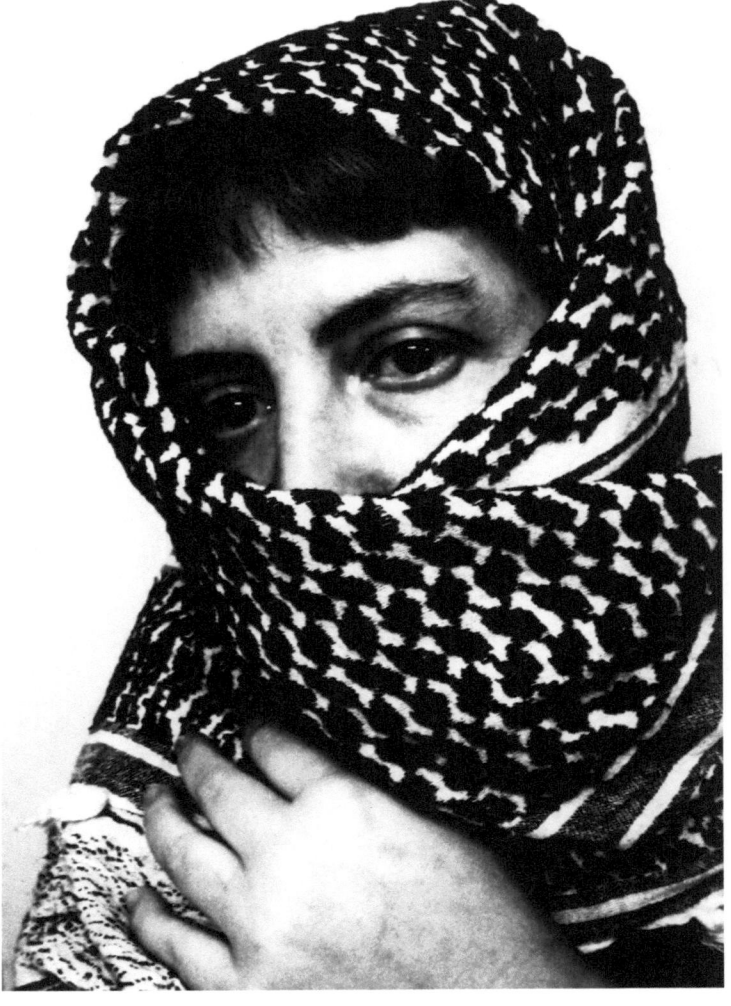

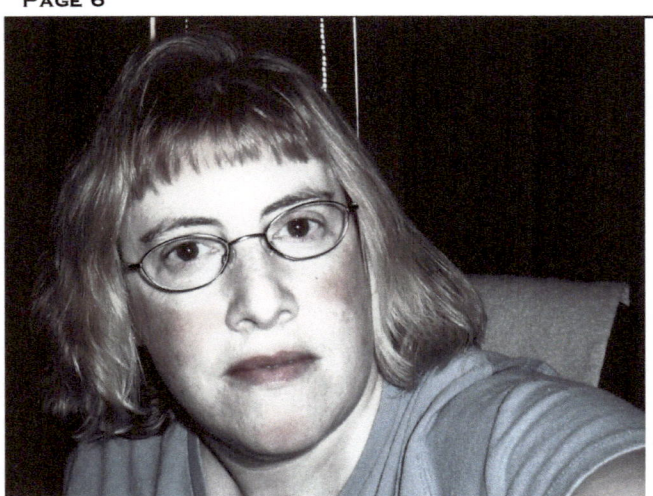
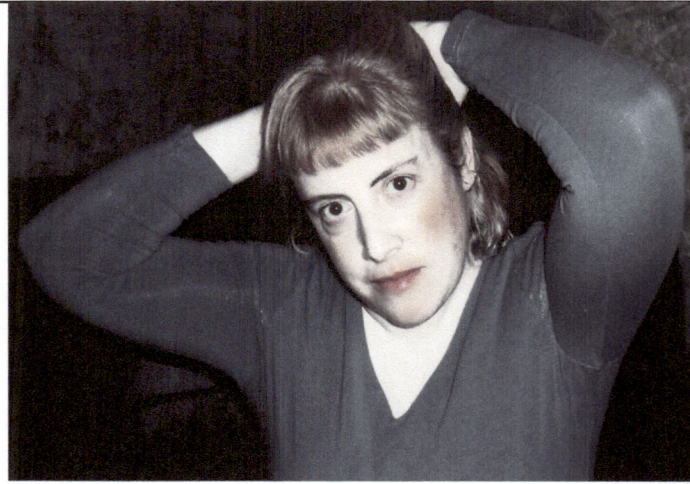

The two self-portraits I took above were grayscaled, then colorized in PhotoShop. The finished photos ended up in the mixed-media self-portrait, below, done on my 45th birthday.

PROMPTS FOR SELF-PORTRAIT ENTHUSIASTS

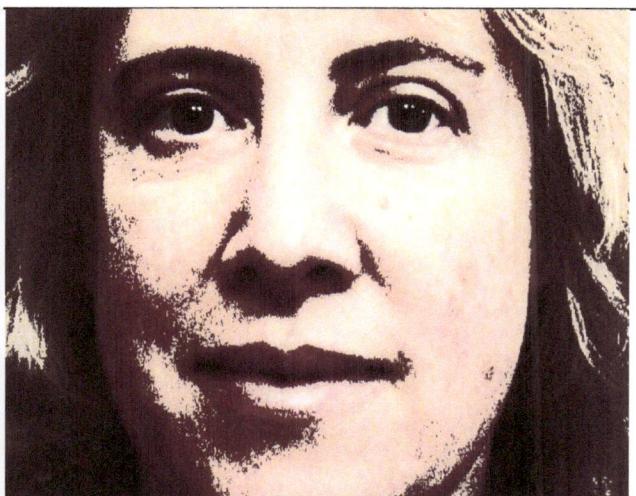

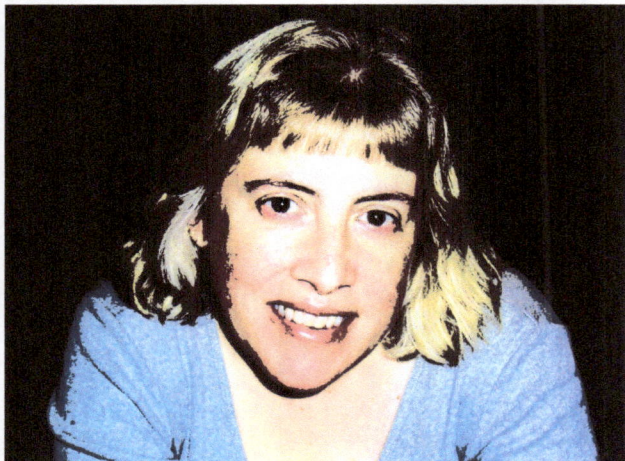

I do a lot of digital manipulation of my photos, in part to make them more visually interesting, and in part because I'm happier with photos of myself if they don't look too much like the real me. Here are three examples of my digital self-portraits that have been reworked in PhotoShop.

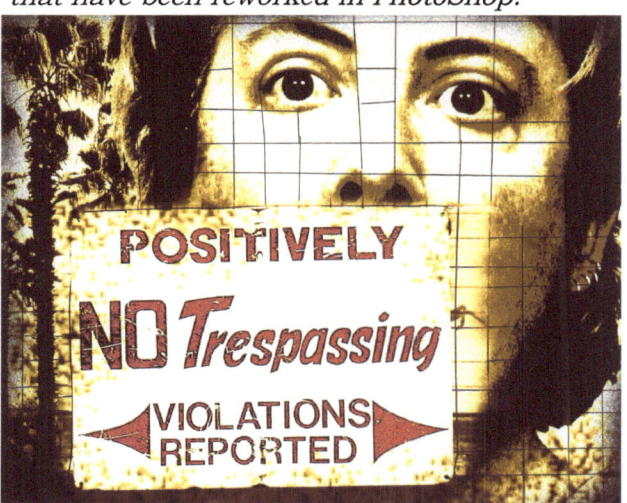

If you'd like to get started doing your own self-portraits, just grab a camera and dive in---but if you need a little support and motivation, there are plenty of groups online that focus on self-portrait photography.

Find these groups on Flickr by doing a search on group titles and descriptions:

Self Portrait Experience is for photos of yourself taken at arm's length. With over 7,000 members and almost 50,000 photos in their pool, there are plenty of ideas to be found here for keeping your self-portraits simple.

365 Days is a group I found through photographer Tamelyn Feinstein (see page 12 for examples of her work, including photos for 365 Days). This group challenges artists to post 365 self-portraits: one each day for a year. Over 20,000 photos have been posted in their pool, so you'll find plenty of ideas for keeping self-portraits varied and interesting.

Creative Self-Portraits is for self-portrait photos that have been manipulated in PhotoShop. For those who enjoy using digital effects, this group's pool of almost 20,000 photos is sure to inspire.

Me With My Camera is all about photos taken in a reflective surface, showing the camera in the image. This is a self-portrait technique just about anyone with a digital camera has tried, so it's a good low-stress starting point. **Mirror Project** is another group that focuses on this type of photo.

For those who are a little camera shy, **A Piece of Me** is for photos that contain any portion of your body. You can start by photographing your hands or feet if that helps you feel more comfortable with the idea of taking pictures of yourself.

Everyday Things Through the Eyes of Diane Ferguson

When I decided on the theme Everyday Things for this issue, I wasn't entirely sure what I'd get from my call for art. Diane Ferguson, whose lovely cemetery photography graced the October issue, rose to the challenge with these five photos. What struck me immediately when I arranged the five together was how unified in color palette they are---Diane's everyday things are all in tones of grey.

A few words from Diane about her photos:

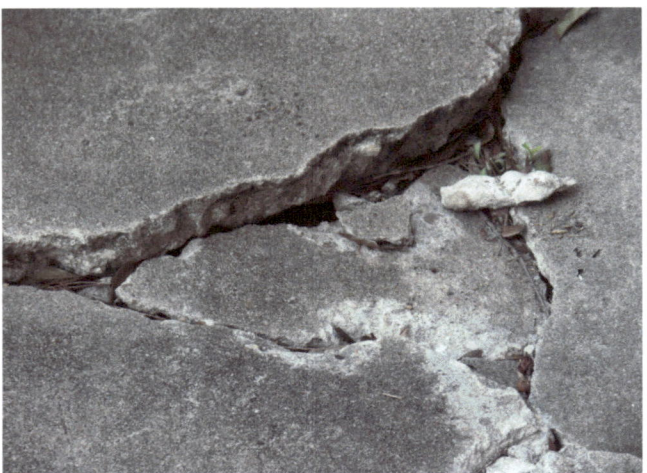

Break Your Mother's Back
"Driveway crack from subsidence in the neighborhood at the edge of a house foundation repair plug. No where but Texas can you watch construction workers bring wheelbarrow loads of liquid concrete into your home."

Trash Bag
"A Wal-Mart bag waiting for today's garbage."

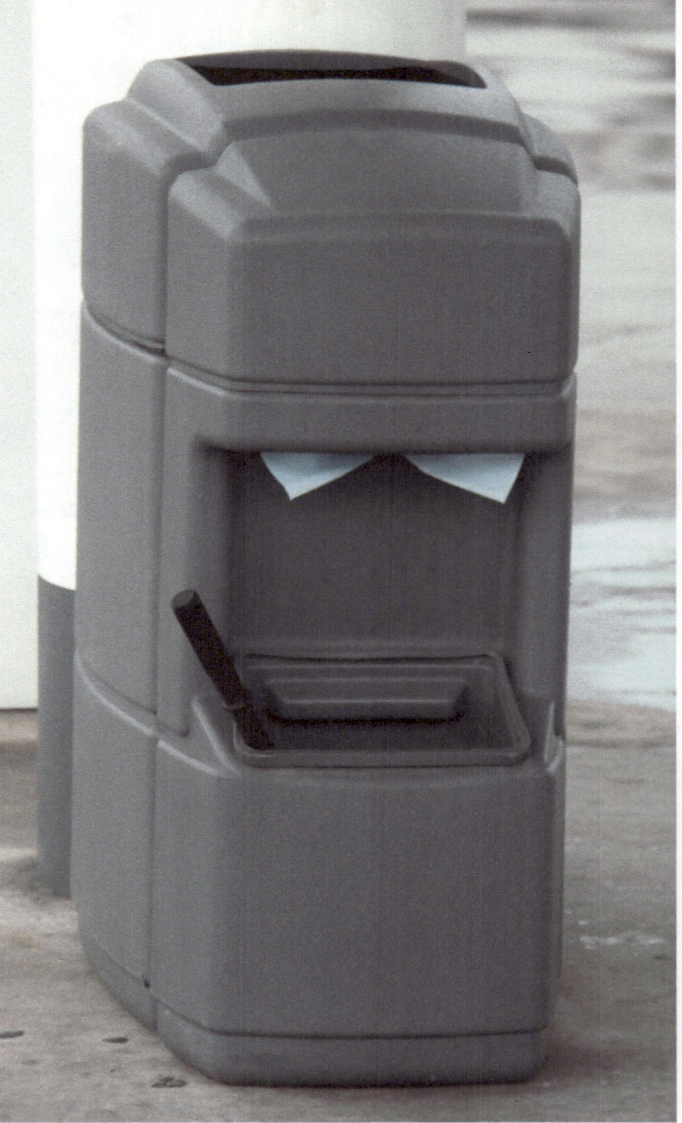

Spooky Trash Can
"I know this is a bit late, but doesn't this look like a Halloween costume?"

Grill
"The grill on the bottom of the refrigerator."

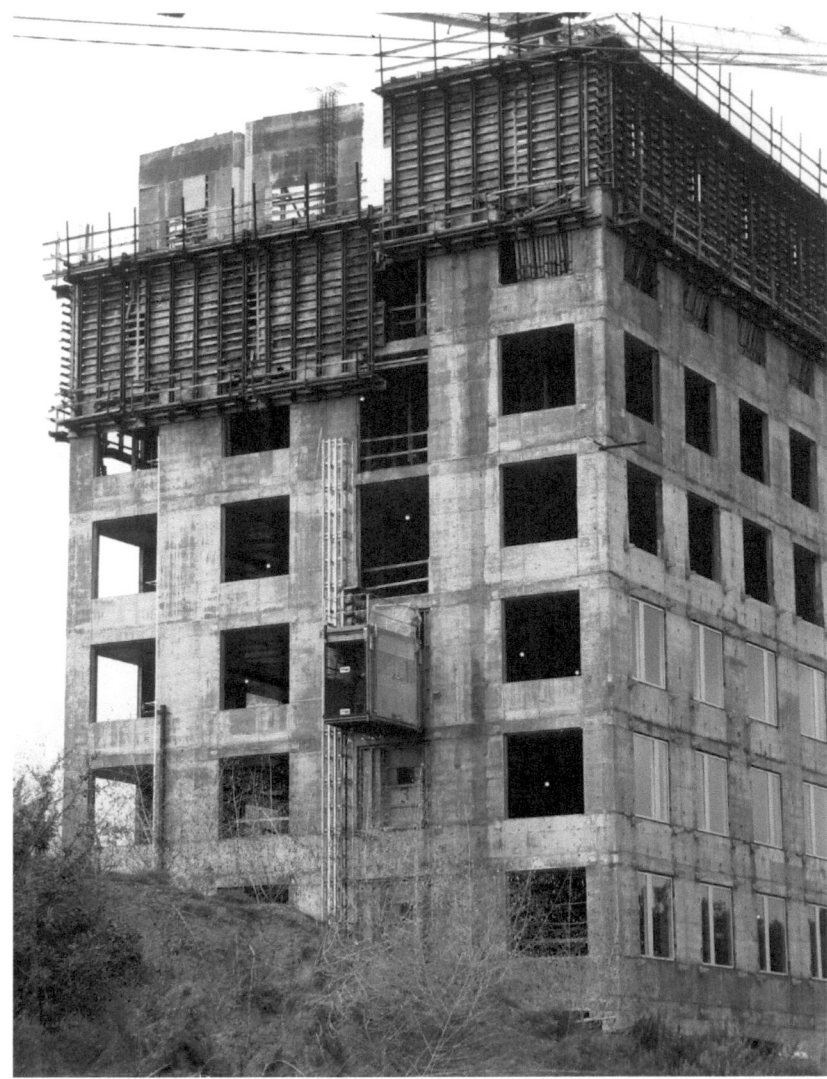

Under Construction
"Building construction amazes me. Progress and process are obvious. Not like my job where I move paper from here to there and back again."

The Art of the Can

What happens when an international corporation sponsors an altered art contest? The answers can be seen in the entries for Red Bull's Art of the Can Contest, which came to my home town last month.

Red Bull challenged entrants to create whatever they wished, using their trademark blue and silver can as their primary material. The Dallas participants created all sorts of cool stuff, from pop-tab jewelry to riding chaps to larger-than-life sculptures. The finished pieces were both hilarious and awe-inspiring. I

'm constantly amazed at how people will use the same material, and this contest really showcased the possibilities of an empty drink can.

I visited the exhibit with a friend who writes for a green web site, focused on helping people in the Dallas metroplex understand what they can do to be more responsible inhabitants of Planet Earth. I suggested she go with me to show her the more light-hearted approach to recycling and reusing.

Red Bull has been running Art of the Can contests since 1997, although this is only the second year they've included sites in the United States. I'm hoping they'll do another round in the US in 2007---this contest is right up my alley!

With the permission of the exhibit monitors, I took a few shots of the pieces from the Dallas contest. More examples from other locations are posted on the Art of the Can web site.

Six Bulls A Blooming by Joyce Hishaw-Willis sort of looked like something from my grandmother's house. Don't touch the flowers---they're sharp!

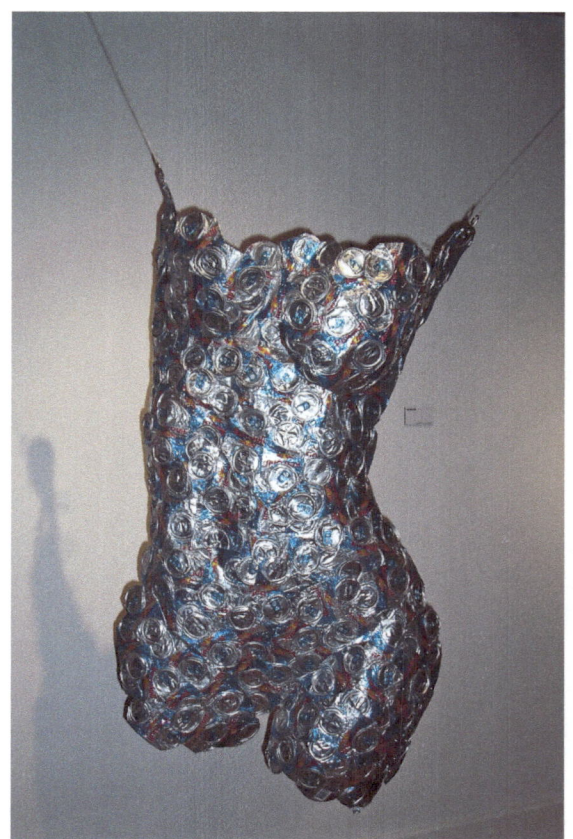

The Beauty of Recycling by Hai Nguyen was a suspended three-dimensional sculpture of a life-sized female torso. This photo doesn't do it justice!

El Toro Rojo by Felipe Contreras (right) used flattened Red Bull cans to create a two-dimensional pieced blue bull.

Hand Me Another by Patsy Davila (below left) showcased some simple pop-tab jewelry.

The Phoenix by Leila Hernandez (below right) was a nicely detailed lighted sculputure

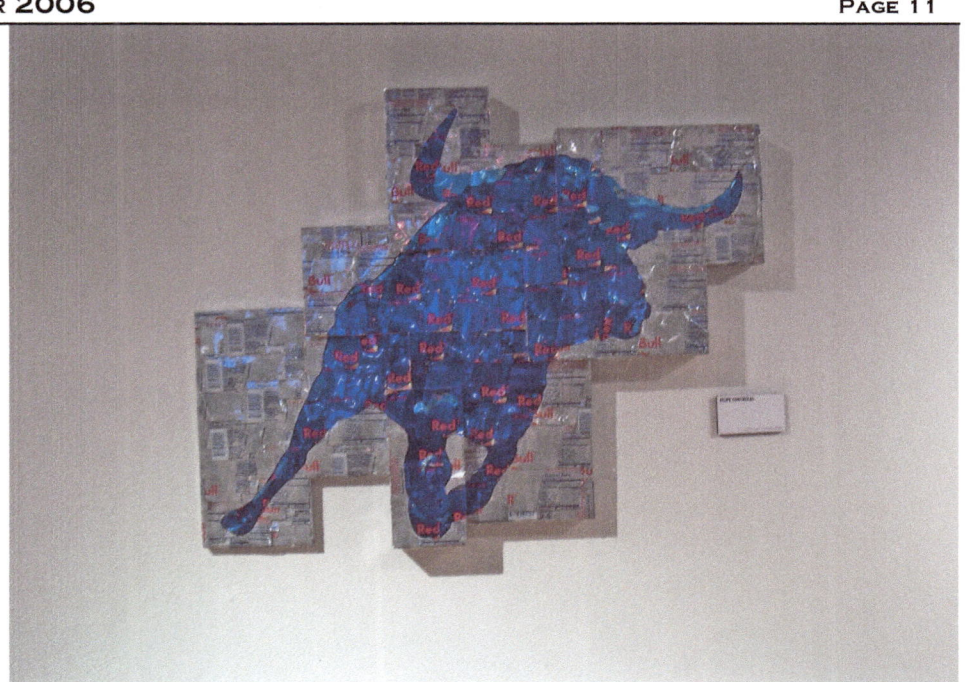

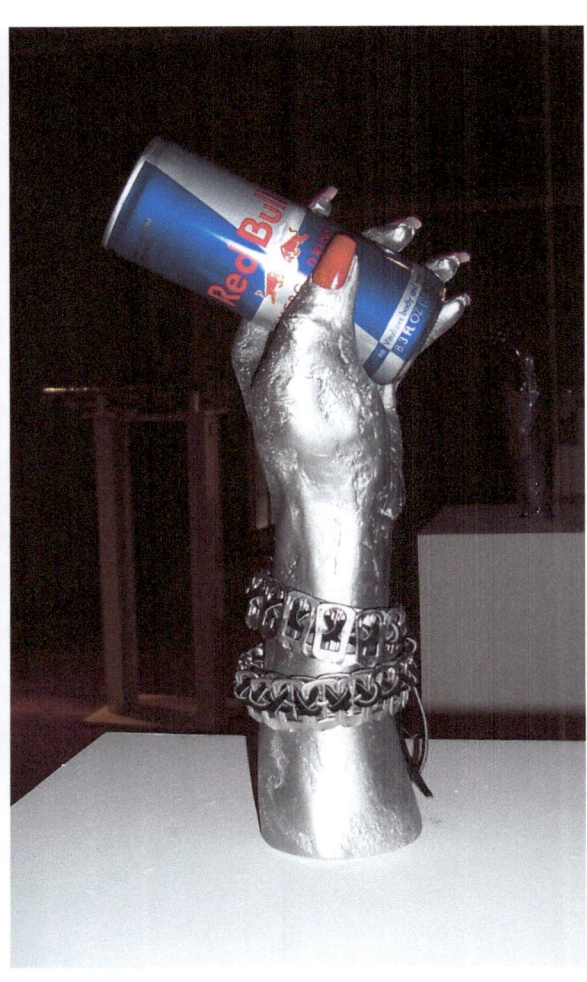

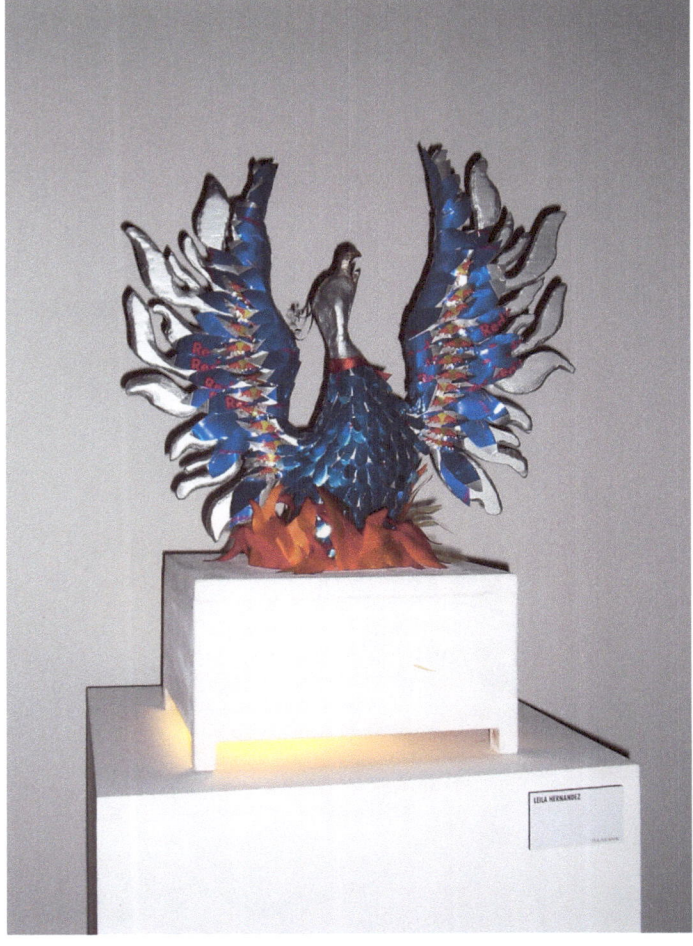

When Tamelyn Feinstein's photos first showed up in one of my Bloglines feeds, I was enchanted. Her work was very personal, but sweet and simple, and often showed a great sense of humor.

I tracked down Tamelyn, and sent her a list of questions to answer for an interview. What I received back was exactly what I loved in her photos---personal and from the heart.

I'll just shut up now, and let Tamelyn tell you about herself:

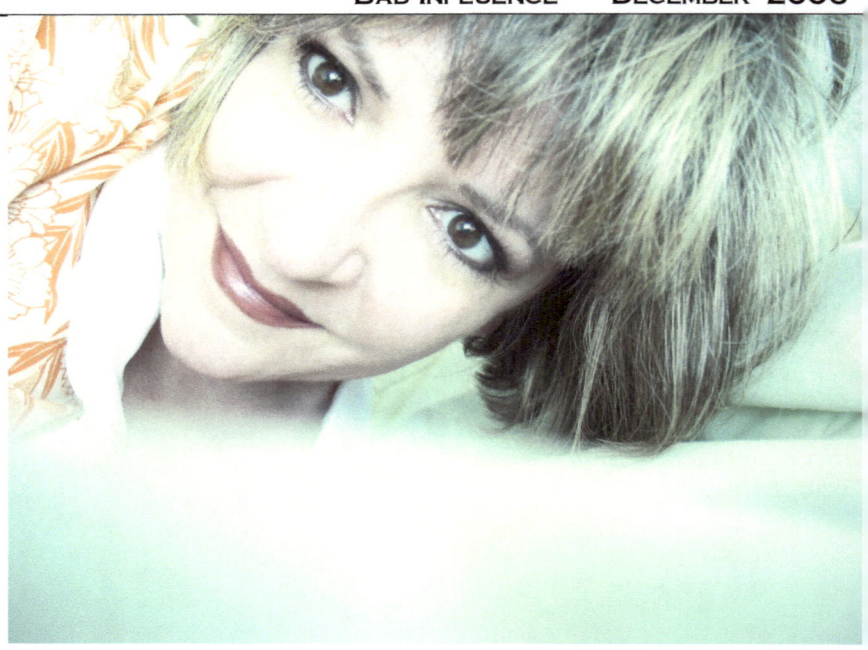

The Not So Everyday World of Tamelyn Feinstein

My name is Tamelyn Feinstein, and I live in Nashville, Tennessee. I'm a native Nashvillian, although I've lived briefly in California and Texas. And I may live elsewhere in the future, who knows? But Nashville is home for now.

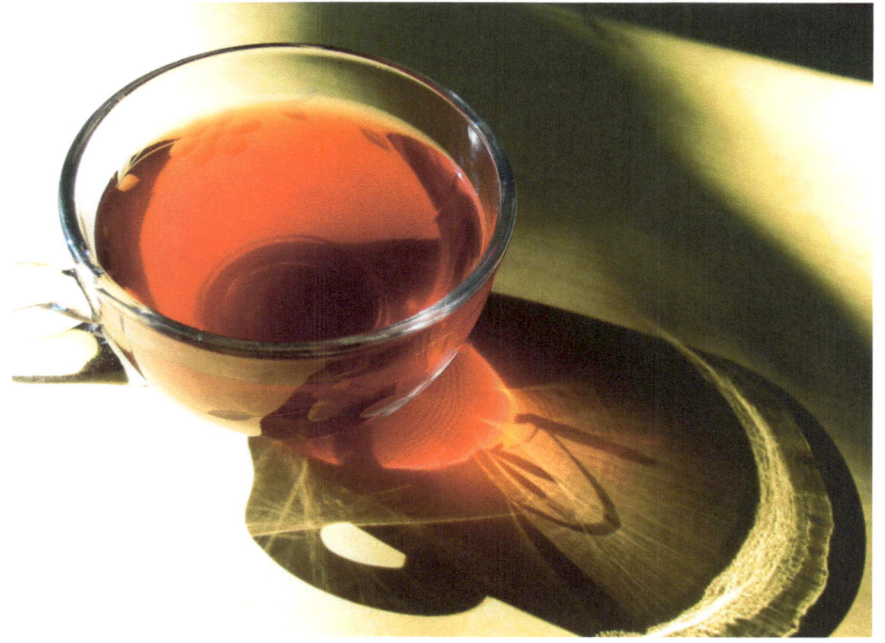

Tamelyn's photos show items from everyday life in beautiful, light-filled detail.

At left, Zing! is a photo of a cut of Red Zinger tea in a clear glass cup.

Above, Kimono Get Happy, one of Tamelyn's self-portrait photos showing her in a light-hearted moment.

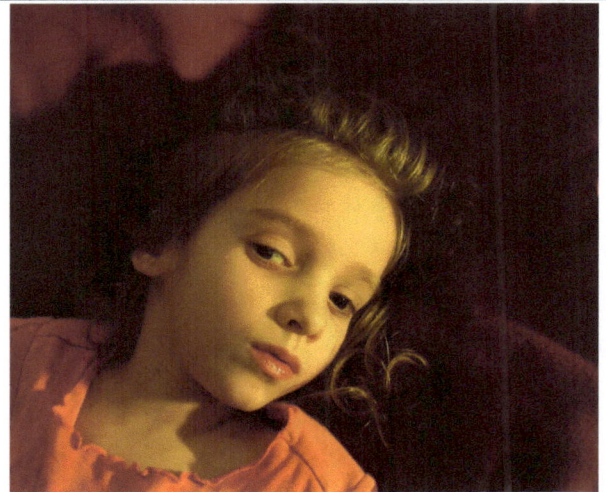

I'm married and I have three children. My oldest child, Brittney, is grown – she's a very talented photographer, and she's been a major influence in my photography recently. My son, Julian, and my daughter, Sofia, also feature prominently in my photography – they are among my favorite subjects to photograph. And I actually met my husband at art school – he has a BFA in photography, and I was completely awed by his photo exhibit before I even met him!

I have a B.S. in art/graphic design, and an M.A. in education. I'm certified to teach art K – 12, although I don't at the moment. I teach art to preschoolers at the local JCC. It's a great fit for my schedule as a working mom, and I love the enthusiasm and purity of the creative process of really young children – they don't yet have a concept of "I can't do this!" or "I have to make this look exactly like _____!" They just do it. Pure process.

On my own time, I paint, draw, work in mixed media / assemblage, do beadwork, embroidery, and different kinds of fabric arts. I've only recently picked up a camera again with the intention of doing creative photography. I took several photography classes in college, and I really enjoyed the creative / conceptual / experimental part of the photographic process, but I never quite got the hang of the technical aspects. That part always made my eyes glaze over. It still does! So after a while I put photography aside except for a means of documenting birthdays and holidays and my other art pieces. I took it up again as a form of creative expression after my daughter, Brittney, began to do so. She encouraged me, and I remembered how fun it used to be.

I don't consider myself a photographer – I'm an artist, and an image-maker. I like taking an image and playing with the color, light, composition. I shoot almost exclusively digital – I have a Canon G2 – and I'm a huge fan of Photoshop. Photoshop has such wonderful effects that mimic the effects some photographers achieve with film – Lomo, cross-processing, different tonal effects – and I can sit and play with those effects for hours. I'd like to try the same effects with film at some point, but I don't have a film camera at the moment. I had a Diana camera and a pinhole camera when I was in school, and I loved the sort of dreamy images they created, but they are long gone.

So photography is definitely something I do for fun. I prefer other artistic media, but I do those for fun, too. Art should always be fun.

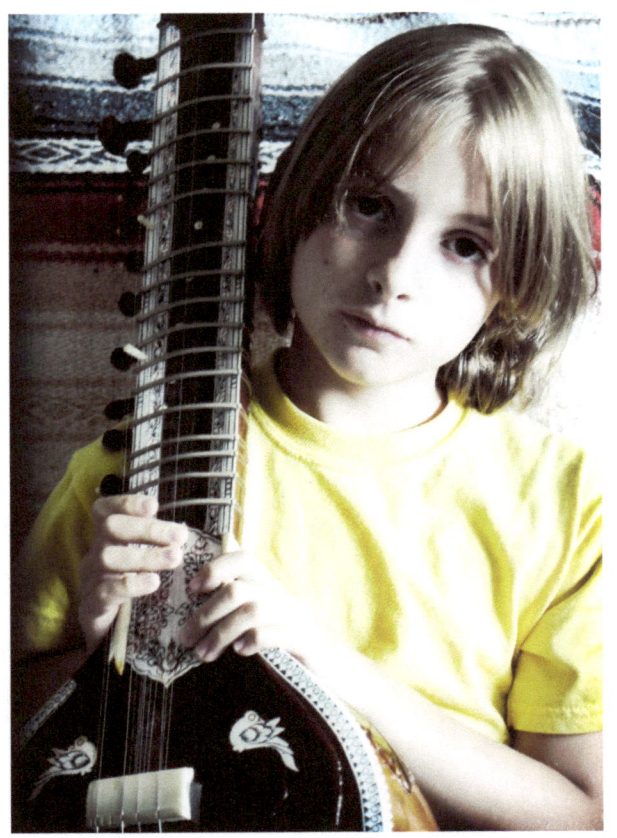

Tamelyn's children occasionally hold still long enough to be captured in their natural elements. Above left: Still, a photo of her daughter Sofia. Above right: Sitar Boy, son Julian.

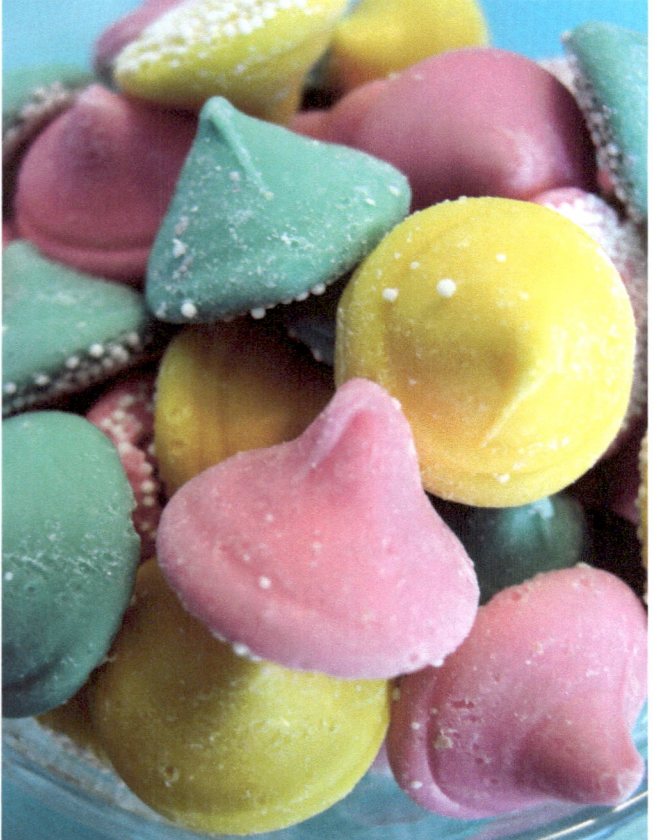

I asked Tamelyn to talk about some specific work I saw in her Flickr photostream. I wanted to hear about her self-portraits for 365 Days.

I began (shooting photos) rather sporadically – I would do a photo here and there, as an idea struck me – a portrait of the kids, or a still life. I didn't begin doing it daily until I decided to join the 365 Days group, which entailed taking a self-portrait a day for a year. Ironically enough, I joined the 365 Days project as a way of overcoming my intense camera-shyness! I thought it would be therapeutic, help me relax in front of a camera, and help me get past some of my appearance / self-esteem issues. I'm a little over two months into the project now, and I'm actually beginning to look forward to the time every day that I shoot my self-portrait. It's sort of a little oasis of "me" time, which is rare when you're a woman with a job, husband, kids…

On this page, two of Tamelyn's fabulously colorful shots of everyday things. Above: Looking Down on Blues. Left: Buttermints for Brittney, Deux

I asked Tamelyn to talk about the things she liked to photograph most, and where she saw her work going in the future.

I am primarily interested in the "up-close-and-personal" – still lifes and portraits. I especially like things that are brightly colored, shiny, reflective, and/or fun. I love taking photos of candy! Candy stores are gorgeous, aren't they? I mean, they don't call something pretty "eye candy" for nothing! And candy appeals to a multitude of senses – it's visual, it's textural, you can imagine how it tastes and smells.

On this page, three of Tamelyn's self-portraits from the 365 Days project. The captions she adds to these photos when she posts them on Flickr reflect her sense of humor.

Above: Cashmere
Left: Do I Look Younger Yet?
Below: I Kneed You

I'm also really fascinated by the way light moves through glass, through liquid, through the lens of the human eye. I love color, both as it appears naturally, and as it looks tweaked through filters and effects, saturated and desaturated.

But my favorite photographic subject is always portraiture, especially when it's raw, honest, emotional. That's something that I hope to achieve in my 365 days portraits at some point. It's also something that's difficult for me. I'm better at "the mask," but I really admire people who can bravely show themselves at their most vulnerable.

I'm also determined to take a portrait of my husband. The only one I have so far is a shot of him sleeping, because he won't pose for me. He's more camera-shy than I am!

Art in a Metal Circle
Manhole Covers

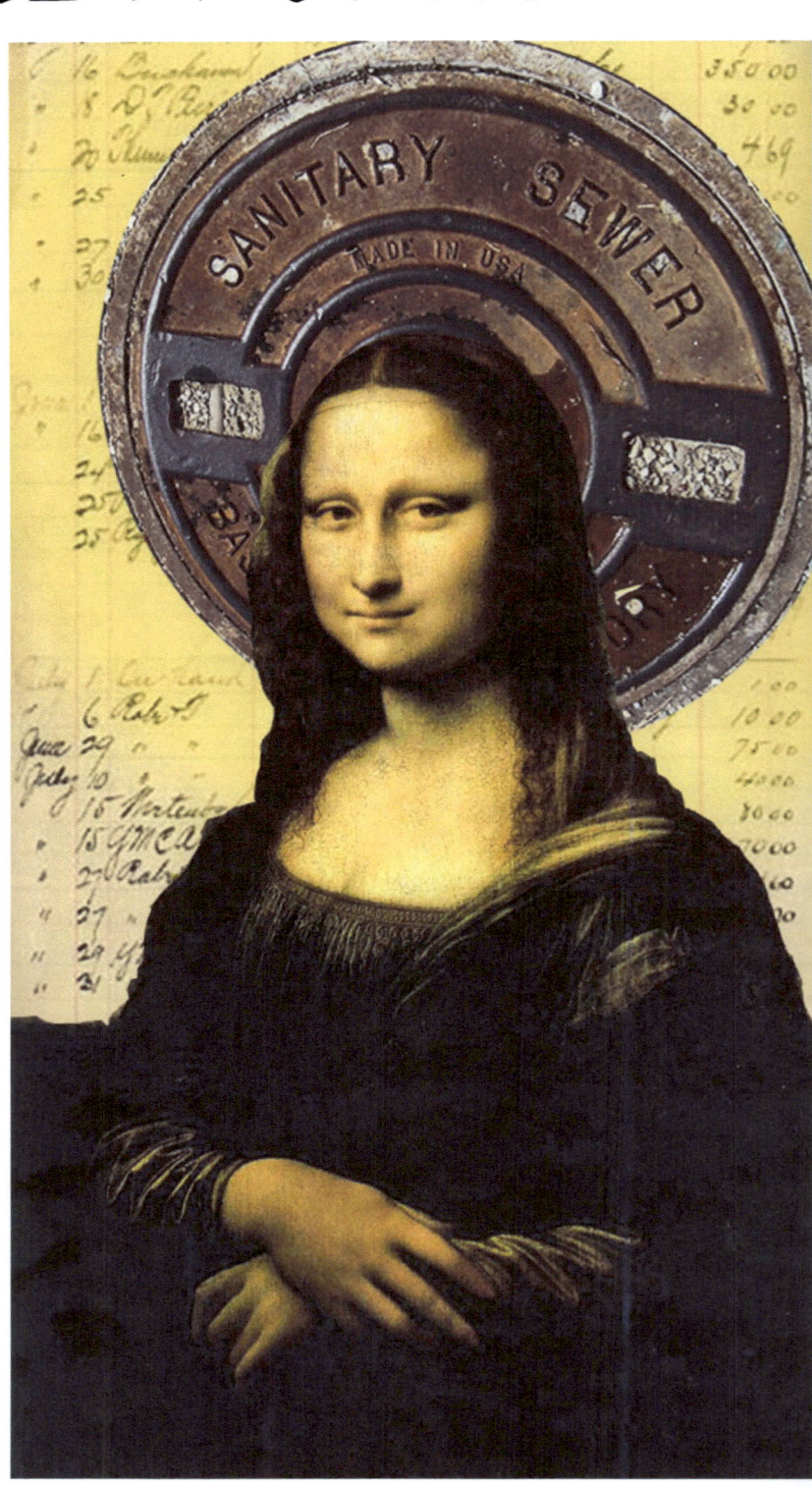

In my never-ending quest to improve my photography skills, I've learned that it's good for me to photograph the same things over and over again, on different days, under different lighting conditions. If I line up ten of my photos of the same subject, I can look at them and pick out one that is ideal, or at least not horrible---good lighting, decent composition, visually interesting, and all those other things that make a photo worthy of not being deleted.

One of the odd things I photograph regularly is manhole covers, or any round, metal cover set into the ground. They're everywhere, and every city has a different design. They're usually conveniently placed in publicly accessible places, like along sidewalks in busy areas, or in the middle of the street in residential areas.

Photographing manhole covers has taught me about framing a good shot. I had to learn to get my feet out of the way, how to stand so that the sun isn't casting my shadow over the subject, and how to angle my camera to get a nice, flat shot. My goal is to get a circle in the center of each frame, rather than an angled oval with its edges cut off. For someone who usually just shoots and runs, this has taught me to really look at what I'm shooting.

I'm always entertained by the mosaics of round object photos people do on Flickr, so I decided to do my own mosaic of manhole cover photos on the facing page. These are shots I took over the summer, walking from home to the post office.

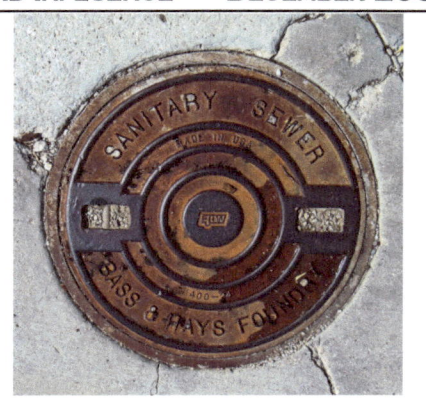
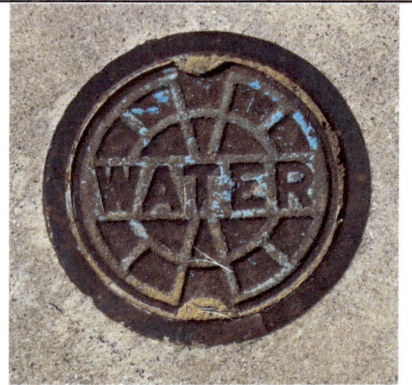
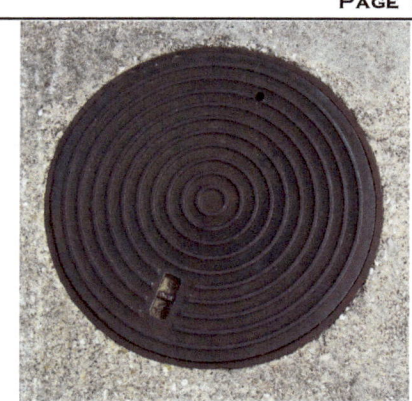
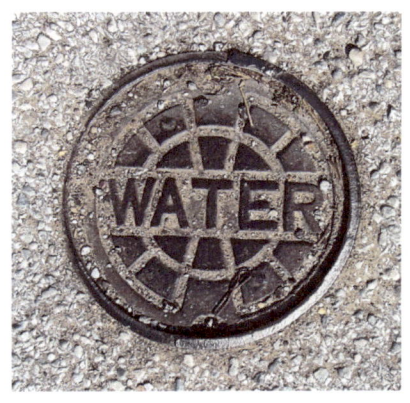
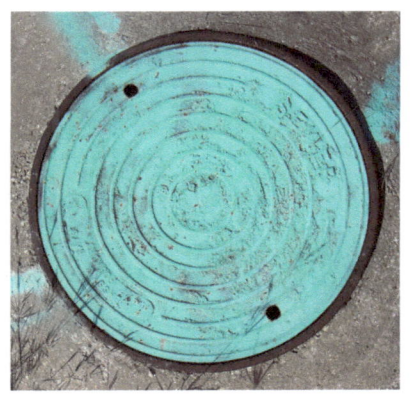
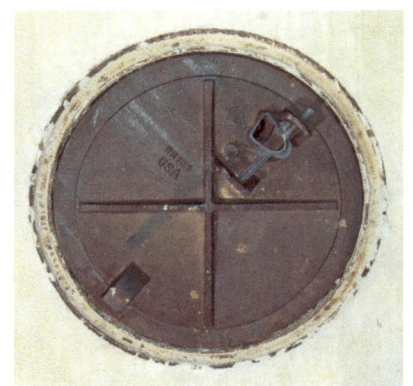
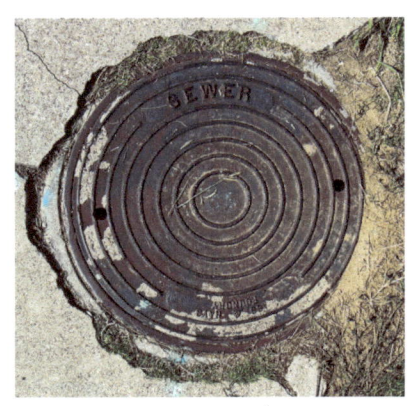
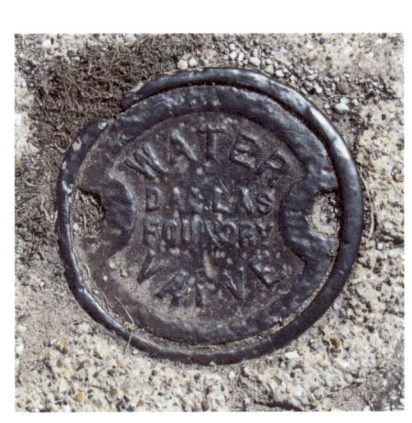
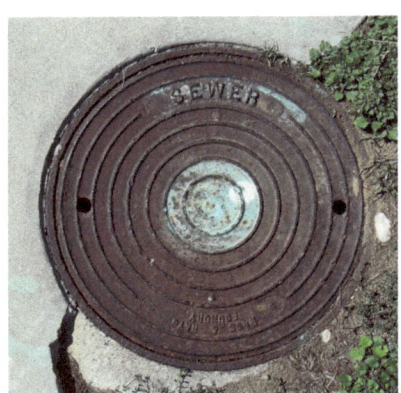
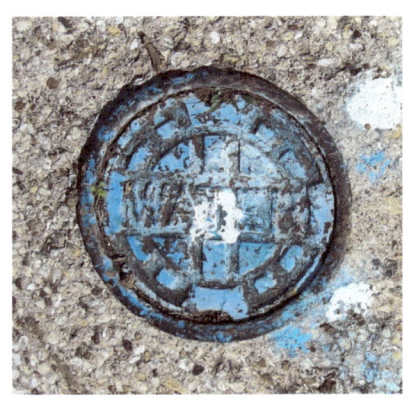
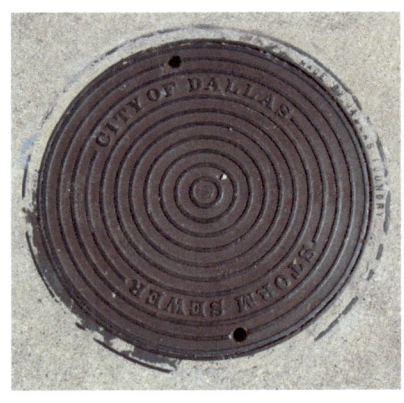
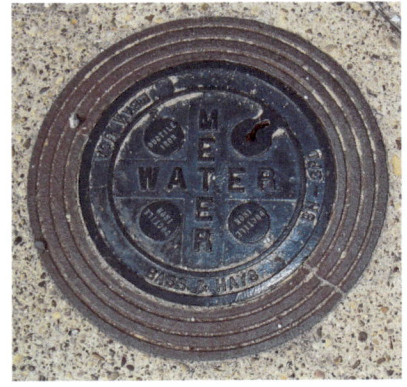

An Everyday Moment From
Jen Worden

After I mentioned this month's theme on the Variest Muse mailing list, multi-talented artist Jen Worden sent me a single photo via email, with this note:

"Thanks for the call or I would never have gotten around to taking this photo, something I've been wanting to do all summer!"

I love the early-morning light in this photo---thanks, Jen!

Morning Ablutions
"This is what I wake up to every morning. Sun streaming through the window creating sparkle in my day."

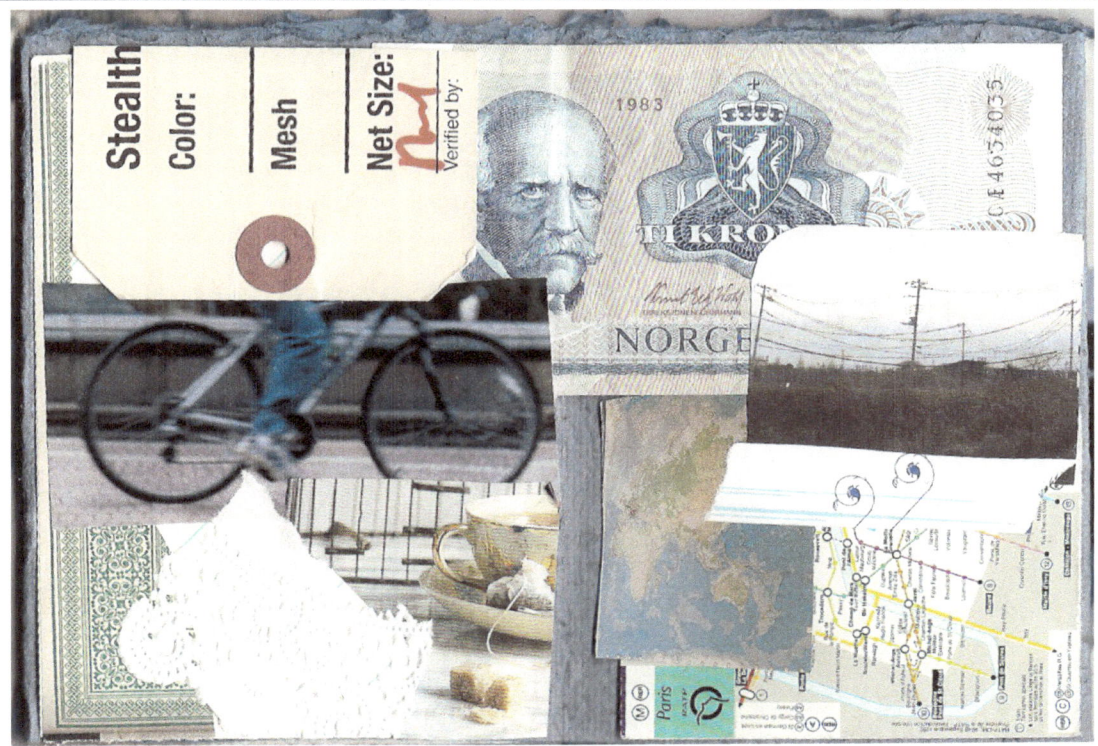

Everyday Collages by Annie Yu

Above: **Daily Routine** - "A small collage piece of a day of a person's life."

Below: **Mystery** - "A small collage piece about things that we carry with us and leave behind."

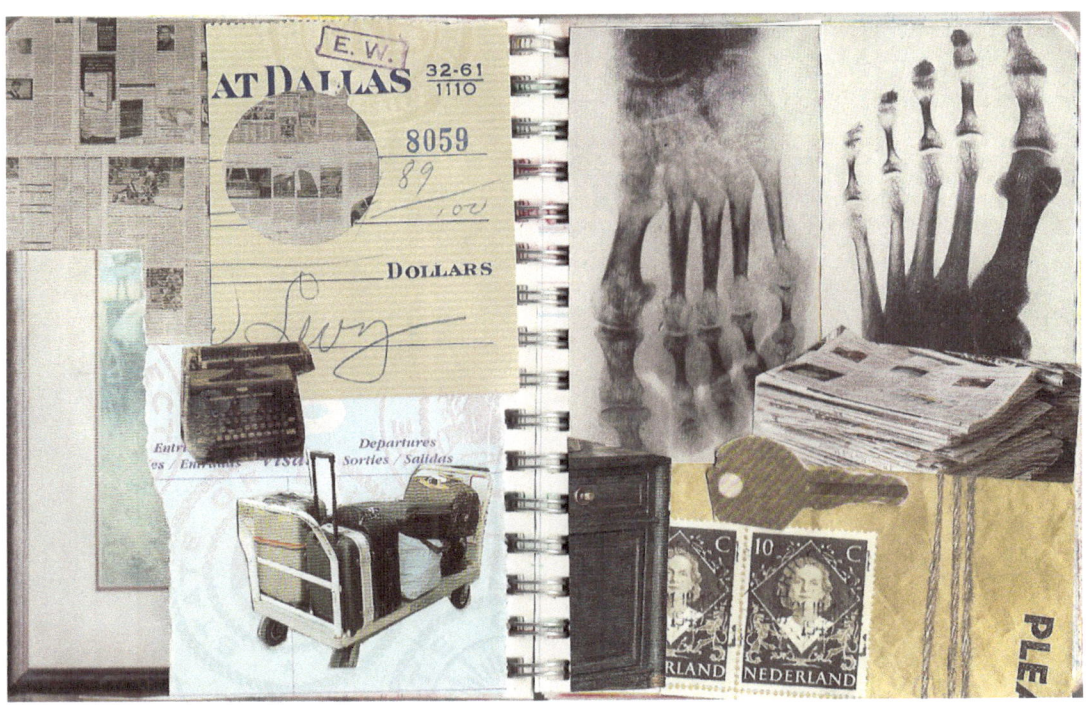

My Dog Weevil

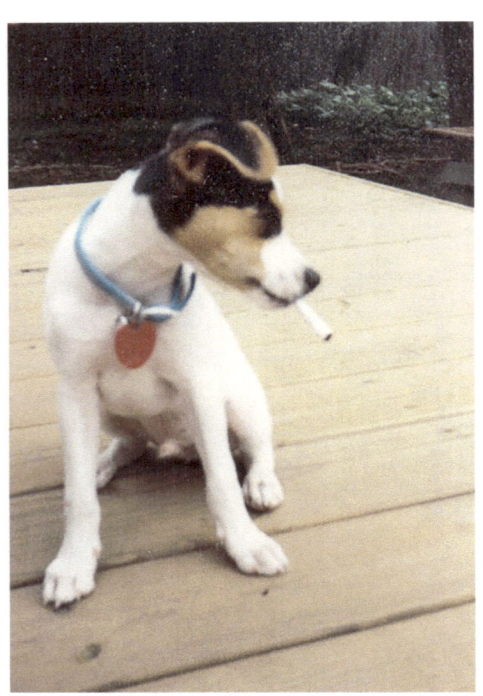

Since I've already mentioned that I photograph the same things over and over again, I guess it's time to talk about the subject I've photographed the most over the years: my dog, Weevil.

I bought Weevil from a farm family when he was six weeks old. He was one of a litter of six, four of which were boys. I cuddled each little boy pup, and each one was equally cute, round, playful and healthy. I couldn't decide. Finally, I looked down at the four pups, and asked them which one would like to come home with me. At that moment, Weevil jumped, and landed flat on his belly on my foot. He chose me.

I started taking photos of The Weev when he was a puppy. Back then, I was still shooting film, so I used to finish up my rolls by shooting a few shots of him. He's always been very photogenic, although he doesn't like the camera a bit, and will slink off with his ears down after a few shots. Unlike manhole covers, Weevil does not remain still, waiting for me to frame a shot. I have to sneak up on him, get him to put his ears up by offering him something he likes, and shoot my shots before he realizes what I'm doing.

Weevil was just a few months old when I caught him outside on the back deck, devouring my boyfriend's cigarette butts (above). I waited patiently for him to turn his head before I caught this shot of him.

Weevil spends most of his day laying on my bed. I turned around this summer, and saw he had moved into a patch of light by the window: white dog on white sheets against a white wall (right).

Weevil shows up in a lot of my firsts, because his image is always readily available. My very first faux postage stamps (far right) were about him.

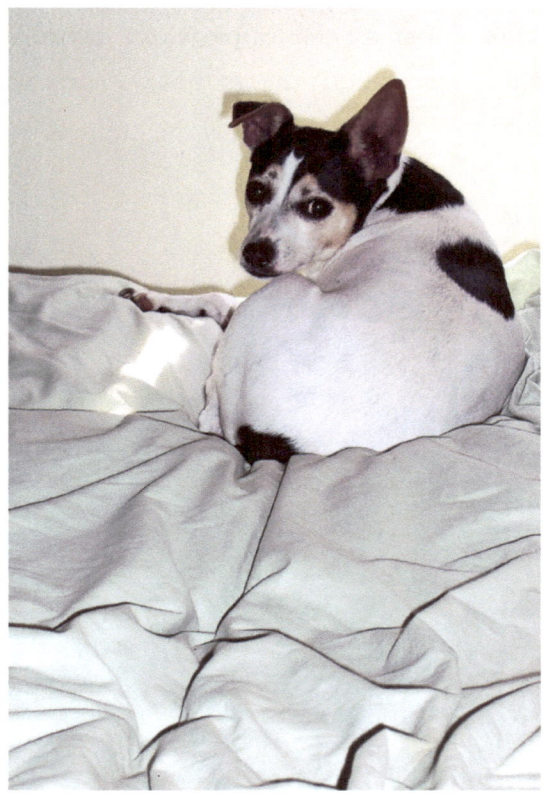

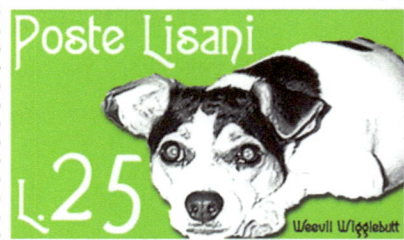
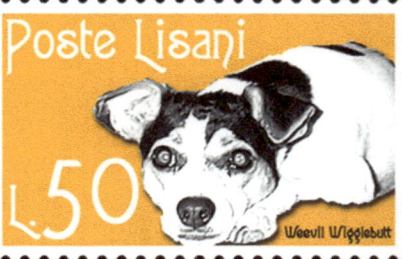
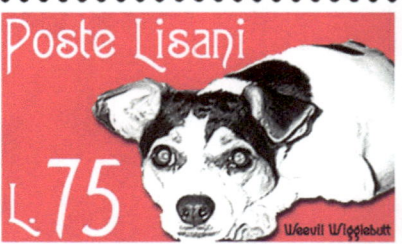

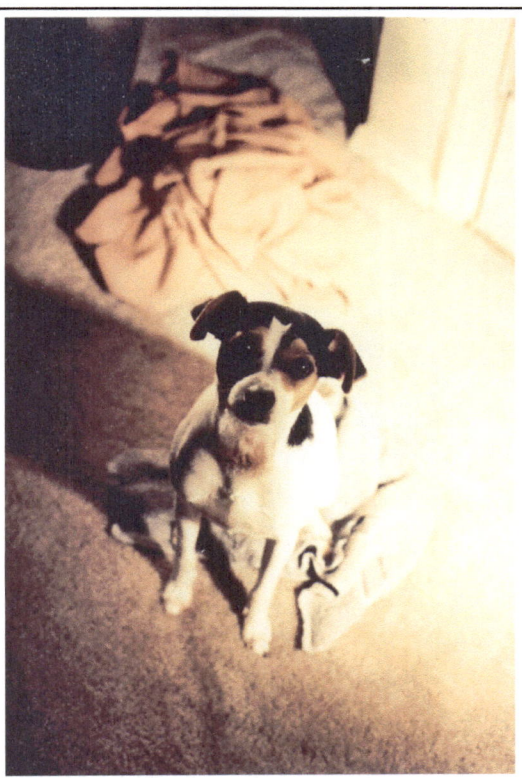 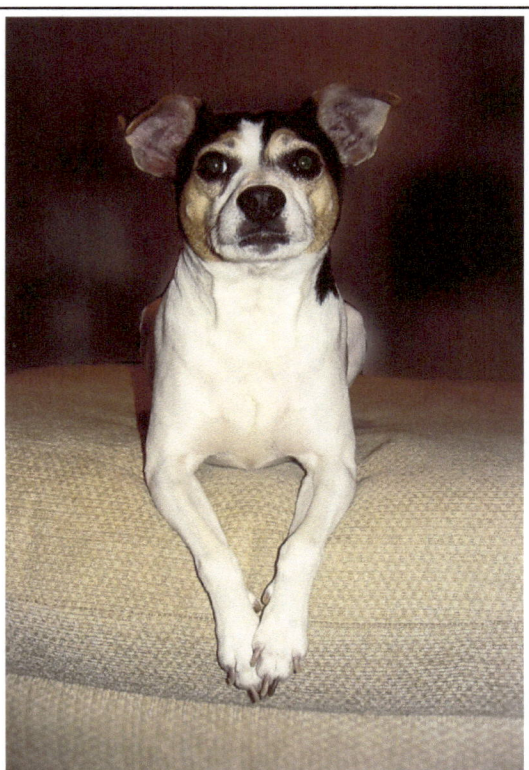

Four photos of The Weev, taken over a ten year period. One of my challenges is to get him to put his ears up, which I've learned to do by getting close to him so he has to look up at me. Getting a good balance of white dog with black eyes is also a challenge, so I occasionally have to retouch the bright green glow cast by my flash.

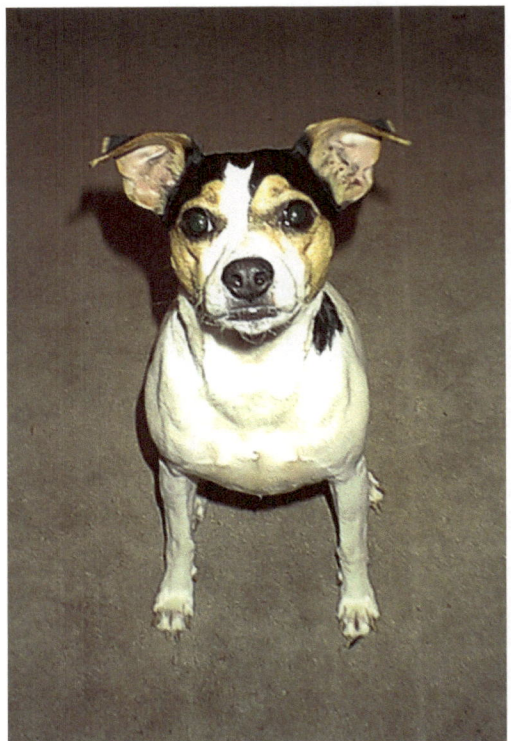 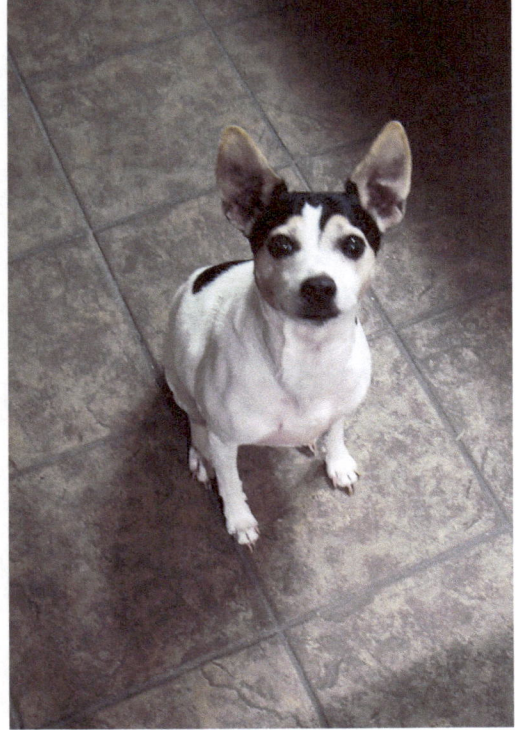

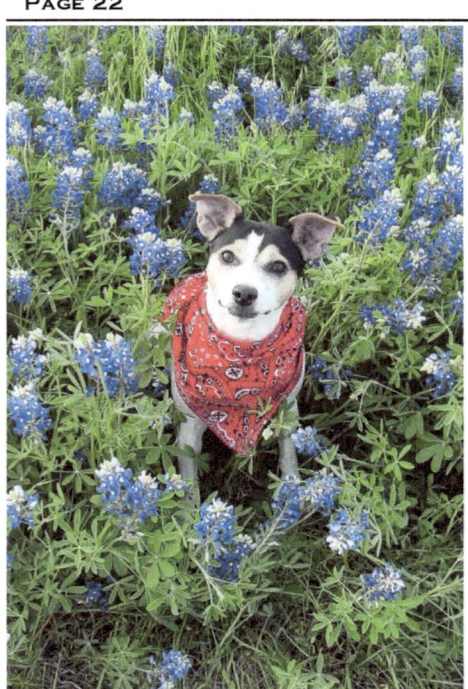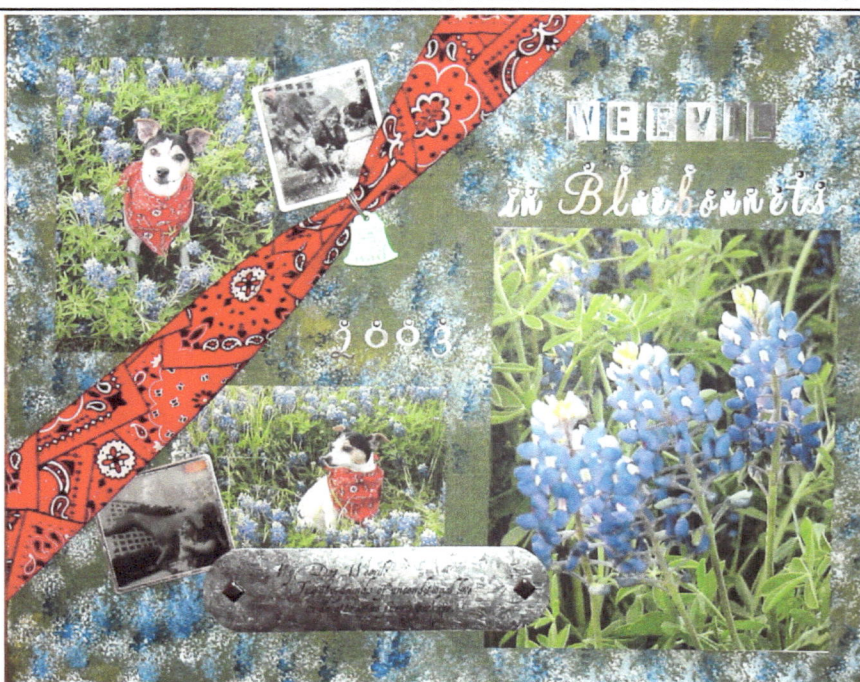

It's a tradition in Texas to take photos in the bluebonnets that bloom each spring, because they're our state flower, and breathtakingly beautiful if we've had a hard enough freeze the previous winter. I took Weevil out for a posed photo shoot, and it took me about an hour and over 100 shots to get the perfect photo shown at upper left. I've used the photos from this shoot in many pieces since then, from the large collage that hangs in my living room (above right), to the artist trading card about happiness (lower left), to a digital fat book page on Warholing (lower right).

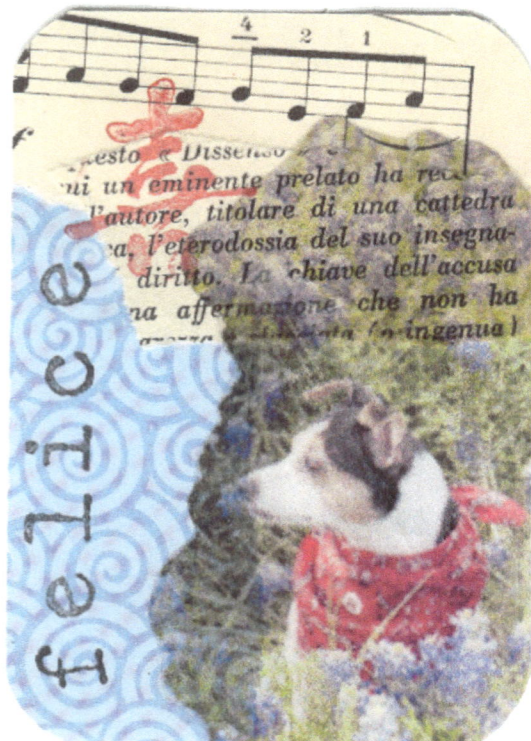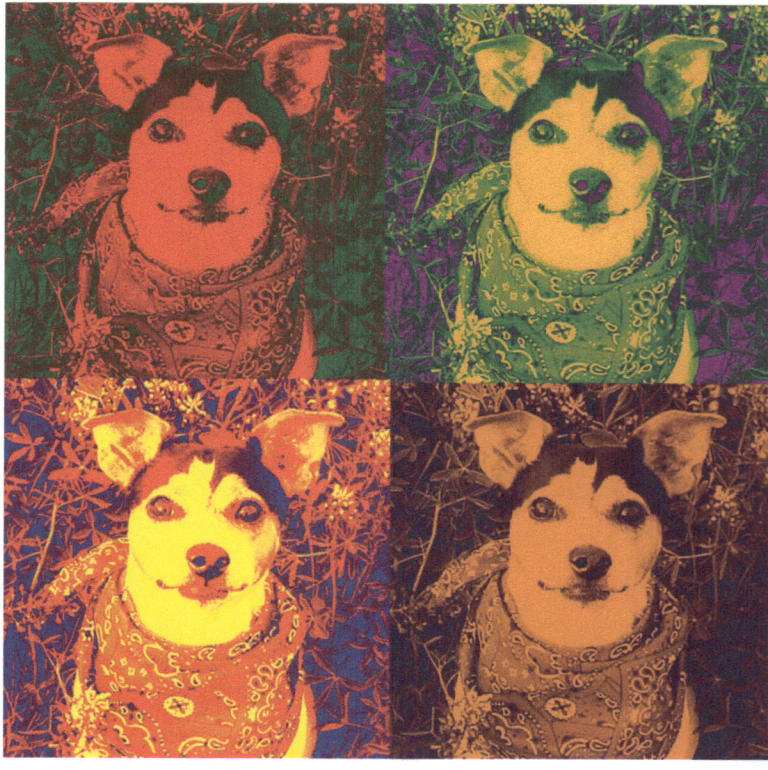

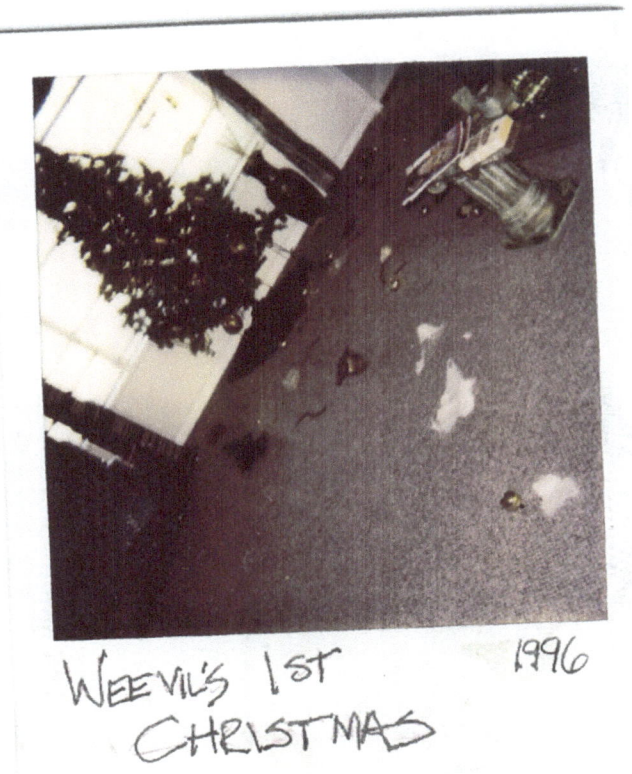 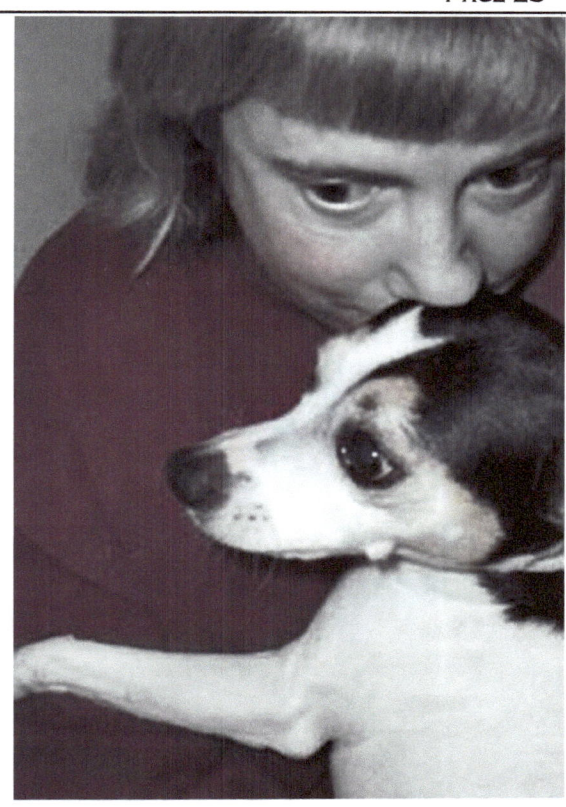

One of my favorite Weevil photos isn't of him at all---it's the Polaroid I took of his Christmas tree adventure the first year I had him (above left).

The photo above right was a quick shot I did last Valentine's Day, for a request on LiveJournal.

Weevil occasionally deigns to leave the comfort of my bed for a small doggie bed on the floor of my work room---but only when the sun is hitting it (lower right). This one ear up and one ear down pose is typical of what I get if I don't move close enough to make him look up at me.

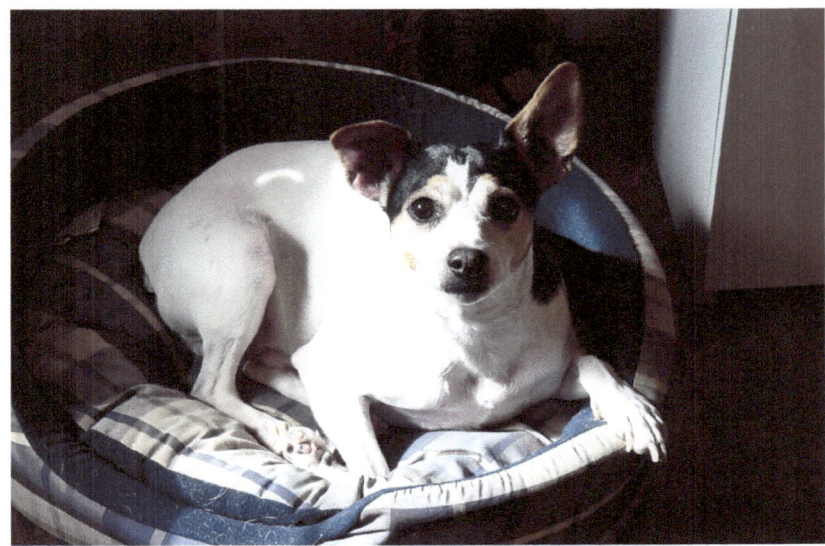

www.ingramcontent.com/pod-product-compliance
Lightning Source LLC
Chambersburg PA
CBHW050437180526
45159CB00006B/2572